Color By Numbers Coloring Book

This Adult Color By Number Book belongs to:

Copyright © 2019 Adult Coloring Books

1. Red
2. Green
3. Blue
4. Pink
5. Purple
6. Light Blue
7. Light Green
8. Orange
9. Dark Red
10. Brown
11. Black
12. Dark Green
13. Gold
14. Violet
15. Yellow

1. Red
2. Green
3. Blue
4. Pink
5. Purple
6. Light Blue
7. Light Green
8. Orange
9. Dark Red
10. Brown
11. Black
12. Dark Green
13. Gold
14. Violet
15. Yellow

1. Red
2. Green
3. Blue
4. Pink
5. Purple
6. Light Blue
7. Light Green
8. Orange
9. Dark Red
10. Brown
11. Black
12. Dark Green
13. Gold
14. Violet
15. Yellow

1. Red
2. Green
3. Blue
4. Pink
5. Purple
6. Light Blue
7. Light Green
8. Orange
9. Dark Red
10. Brown
11. Black
12. Dark Green
13. Gold
14. Violet
15. Yellow

1. Red
2. Green
3. Blue
4. Pink
5. Purple
6. Light Blue
7. Light Green
8. Orange
9. Dark Red
10. Brown
11. Black
12. Dark Green
13. Gold
14. Violet
15. Yellow

1. Red
2. Green
3. Blue
4. Pink
5. Purple
6. Light Blue
7. Light Green
8. Orange
9. Dark Red
10. Brown
11. Black
12. Dark Green
13. Gold
14. Violet
15. Yellow

1. Red
2. Green
3. Blue
4. Pink
5. Purple
6. Light Blue
7. Light Green
8. Orange
9. Dark Red
10. Brown
11. Black
12. Dark Green
13. Gold
14. Violet
15. Yellow

1. Blue
2. Dark Blue
3. Black
4. Yellow
5. Green
6. Brown
7. Dark Blue
8. Gold
9. Dark Green
10. Purple

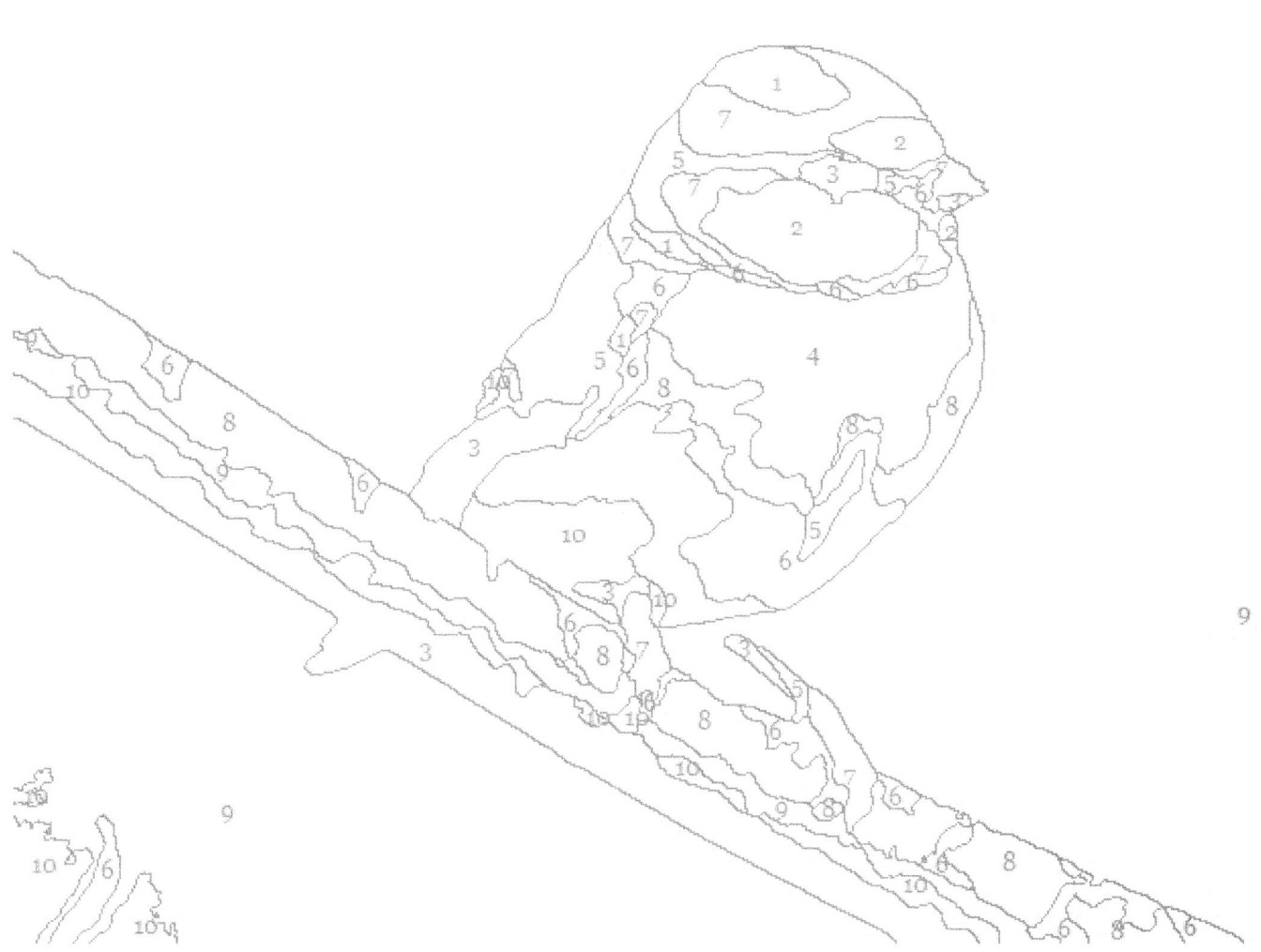

1. Red
2. Green
3. Blue
4. Pink
5. Purple
6. Light Blue
7. Light Green
8. Orange
9. Dark Red
10. Brown
11. Black
12. Dark Green
13. Gold
14. Violet
15. Yellow

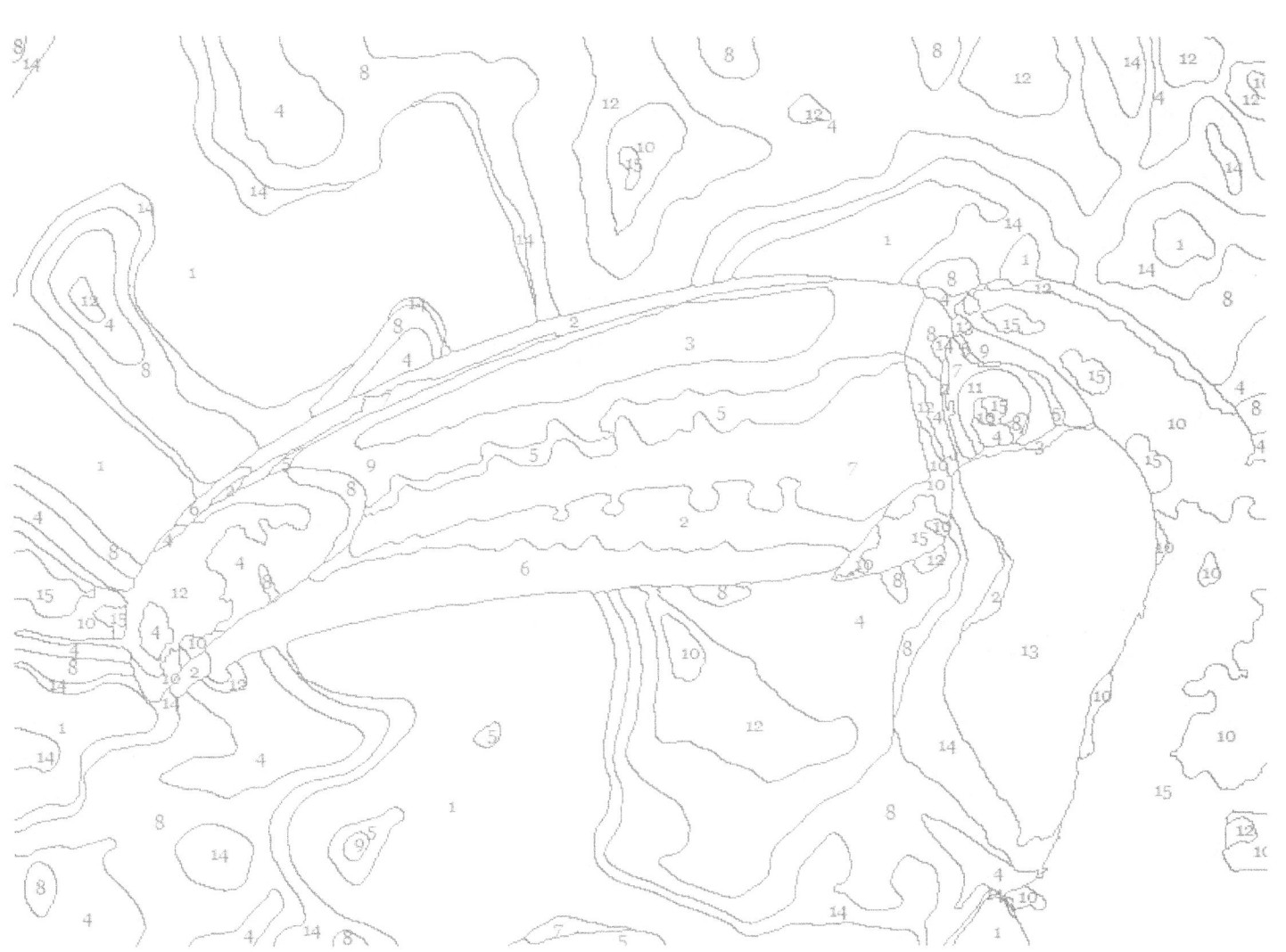

1. Red
2. Green
3. Blue
4. Pink
5. Purple
6. Light Blue
7. Light Green
8. Orange
9. Dark Red
10. Brown
11. Black
12. Dark Green
13. Gold
14. Violet
15. Yellow

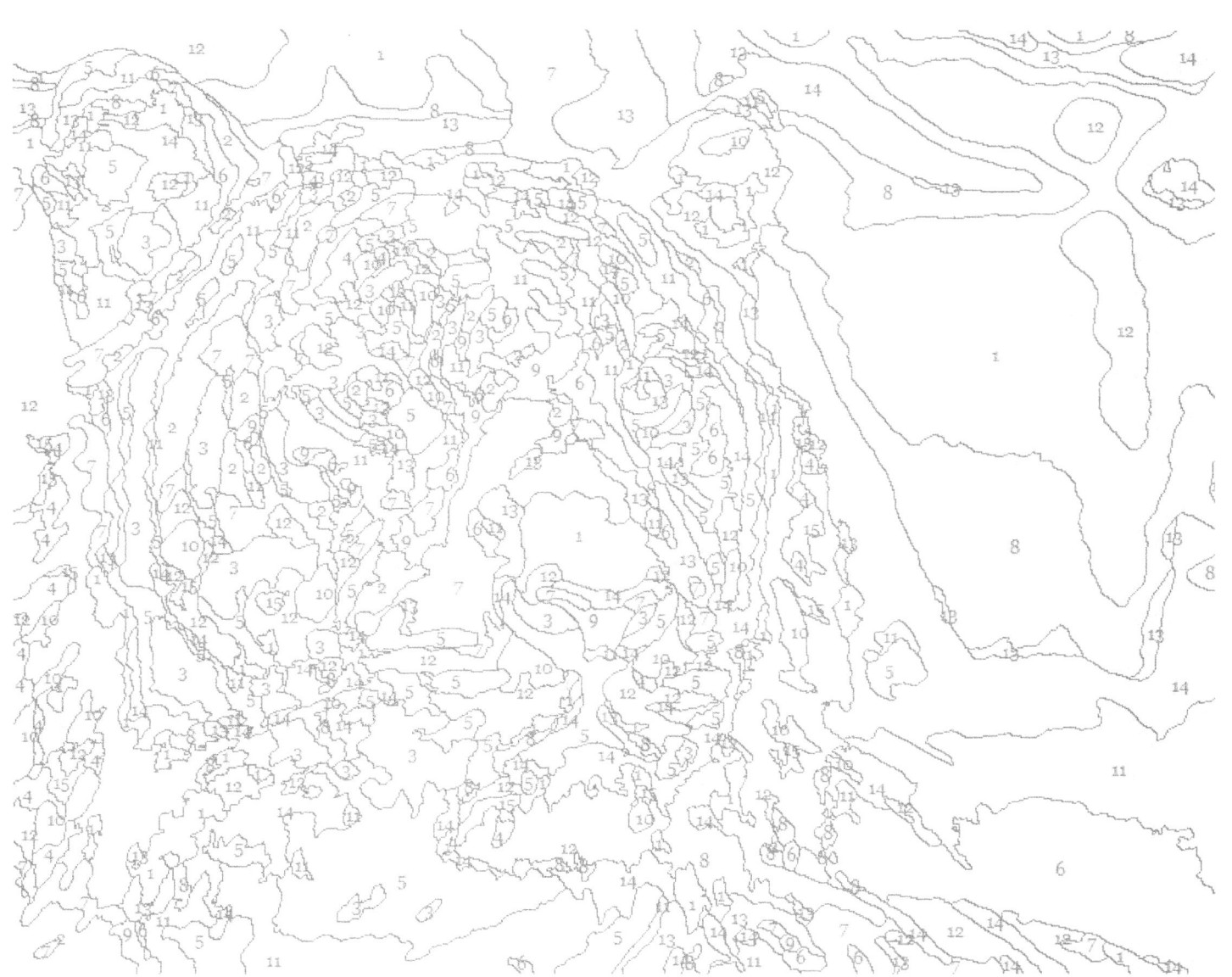

1. Red
2. Green
3. Blue
4. Pink
5. Purple
6. Light Blue
7. Light Green
8. Orange
9. Dark Red
10. Brown
11. Black
12. Dark Green
13. Gold
14. Violet
15. Yellow

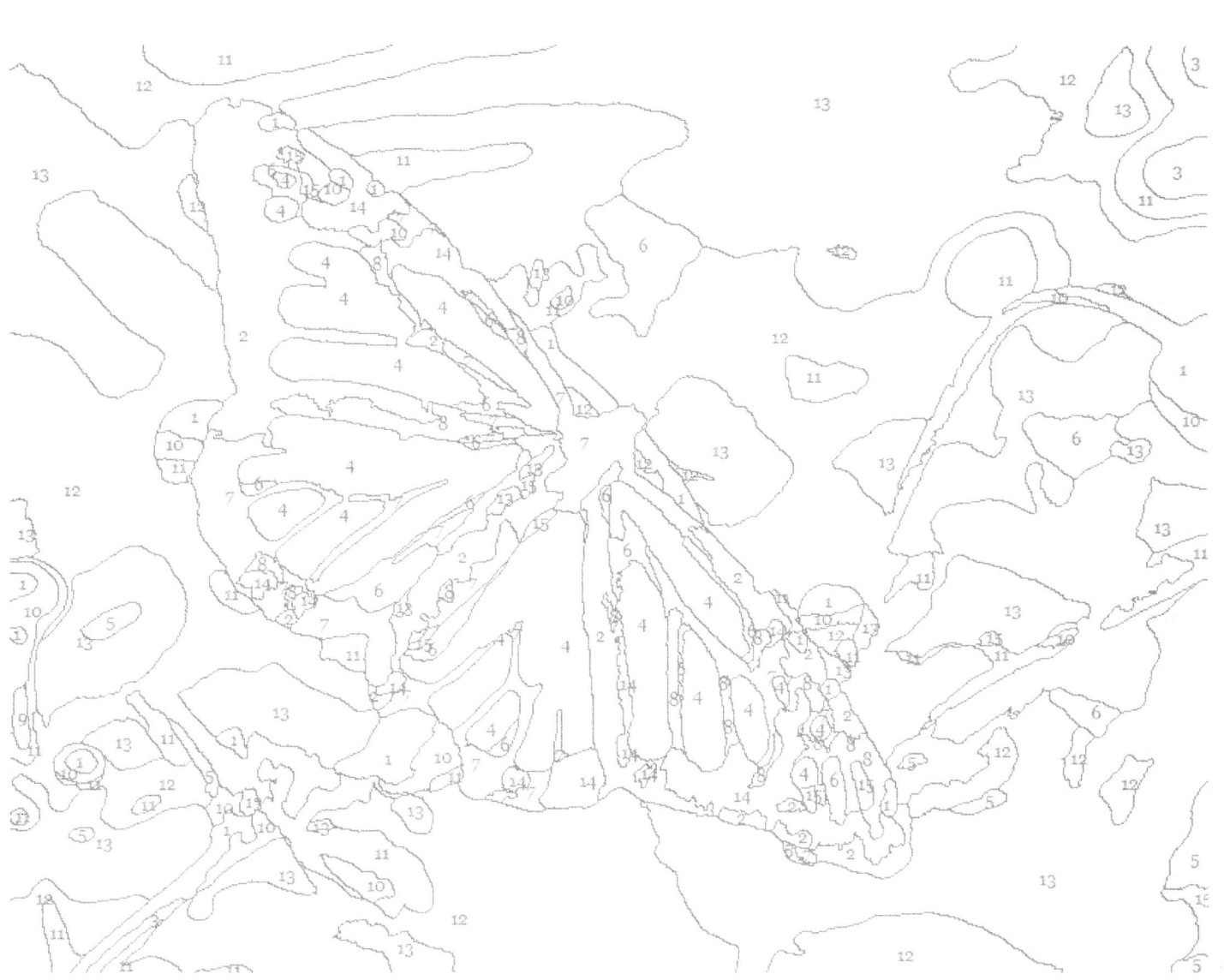

1. Red
2. Green
3. Blue
4. Pink
5. Purple
6. Light Blue
7. Light Green
8. Orange
9. Dark Red
10. Brown
11. Black
12. Dark Green
13. Gold
14. Violet
15. Yellow

1. Red
2. Green
3. Blue
4. Pink
5. Purple
6. Light Blue
7. Light Green
8. Orange
9. Dark Red
10. Brown
11. Black
12. Dark Green
13. Gold
14. Violet
15. Yellow

1. Red
2. Green
3. Blue
4. Pink
5. Purple
6. Light Blue
7. Light Green
8. Orange
9. Dark Red
10. Brown
11. Black
12. Dark Green
13. Gold
14. Violet
15. Yellow

1. Red
2. Green
3. Blue
4. Pink
5. Purple
6. Light Blue
7. Light Green
8. Orange
9. Dark Red
10. Brown
11. Black
12. Dark Green
13. Gold
14. Violet
15. Yellow

1. Red
2. Green
3. Blue
4. Pink
5. Purple
6. Light Blue
7. Light Green
8. Orange
9. Dark Red
10. Brown
11. Black
12. Dark Green
13. Gold
14. Violet
15. Yellow

1. Red
2. Green
3. Blue
4. Pink
5. Purple
6. Light Blue
7. Light Green
8. Orange
9. Dark Red
10. Brown
11. Black
12. Dark Green
13. Gold
14. Violet
15. Yellow

1. Red
2. Green
3. Blue
4. Pink
5. Purple
6. Light Blue
7. Light Green
8. Orange
9. Dark Red
10. Brown
11. Black
12. Dark Green
13. Gold
14. Violet
15. Yellow

1. Red
2. Green
3. Blue
4. Pink
5. Purple
6. Light Blue
7. Light Green
8. Orange
9. Dark Red
10. Brown
11. Black
12. Dark Green
13. Gold
14. Violet
15. Yellow

1. Red
2. Green
3. Blue
4. Pink
5. Purple
6. Light Blue
7. Light Green
8. Orange
9. Dark Red
10. Brown
11. Black
12. Dark Green
13. Gold
14. Violet
15. Yellow

1. Red
2. Green
3. Blue
4. Pink
5. Purple
6. Light Blue
7. Light Green
8. Orange
9. Dark Red
10. Brown
11. Black
12. Dark Green
13. Gold
14. Violet
15. Yellow

1. Red
2. Green
3. Blue
4. Pink
5. Purple
6. Light Blue
7. Light Green
8. Orange
9. Dark Red
10. Brown
11. Black
12. Dark Green
13. Gold
14. Violet
15. Yellow

1. Red
2. Green
3. Blue
4. Pink
5. Purple
6. Light Blue
7. Light Green
8. Orange
9. Dark Red
10. Brown
11. Black
12. Dark Green
13. Gold
14. Violet
15. Yellow

1. Red
2. Green
3. Blue
4. Pink
5. Purple
6. Light Blue
7. Light Green
8. Orange
9. Dark Red
10. Brown
11. Black
12. Dark Green
13. Gold
14. Violet
15. Yellow

1. Red
2. Green
3. Blue
4. Pink
5. Purple
6. Light Blue
7. Light Green
8. Orange
9. Dark Red
10. Brown
11. Black
12. Dark Green
13. Gold
14. Violet
15. Yellow

1. Red
2. Green
3. Blue
4. Pink
5. Purple
6. Light Blue
7. Light Green
8. Orange
9. Dark Red
10. Brown
11. Black
12. Dark Green
13. Gold
14. Violet
15. Yellow

1. Red
2. Green
3. Blue
4. Pink
5. Purple
6. Light Blue
7. Light Green
8. Orange
9. Dark Red
10. Brown
11. Black
12. Dark Green
13. Gold
14. Violet
15. Yellow

1. Red
2. Green
3. Blue
4. Pink
5. Purple
6. Light Blue
7. Light Green
8. Orange
9. Dark Red
10. Brown
11. Black
12. Dark Green
13. Gold
14. Violet
15. Yellow

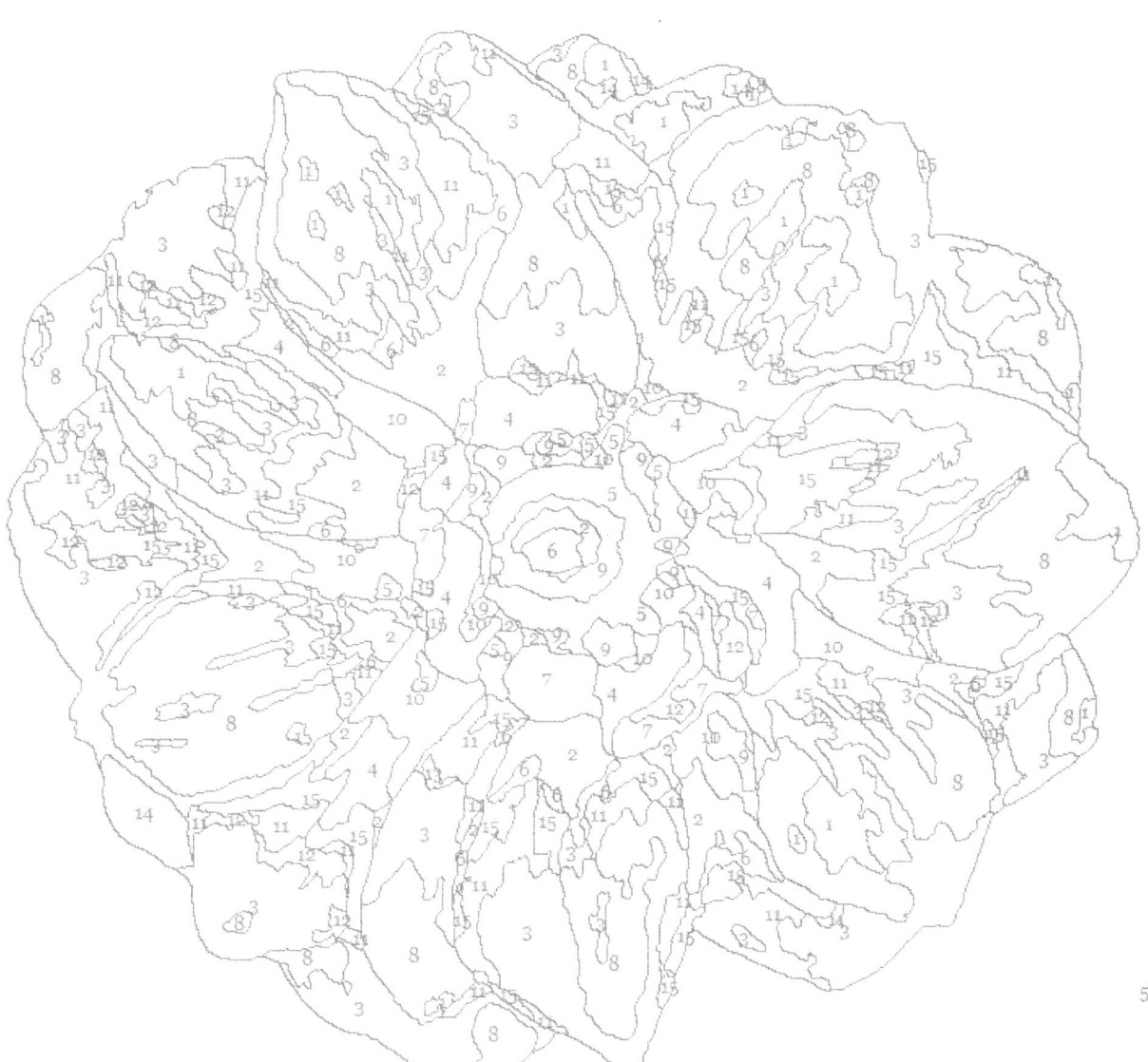

1. Red
2. Green
3. Blue
4. Pink
5. Purple
6. Light Blue
7. Light Green
8. Orange
9. Dark Red
10. Brown
11. Black
12. Dark Green
13. Gold
14. Violet
15. Yellow

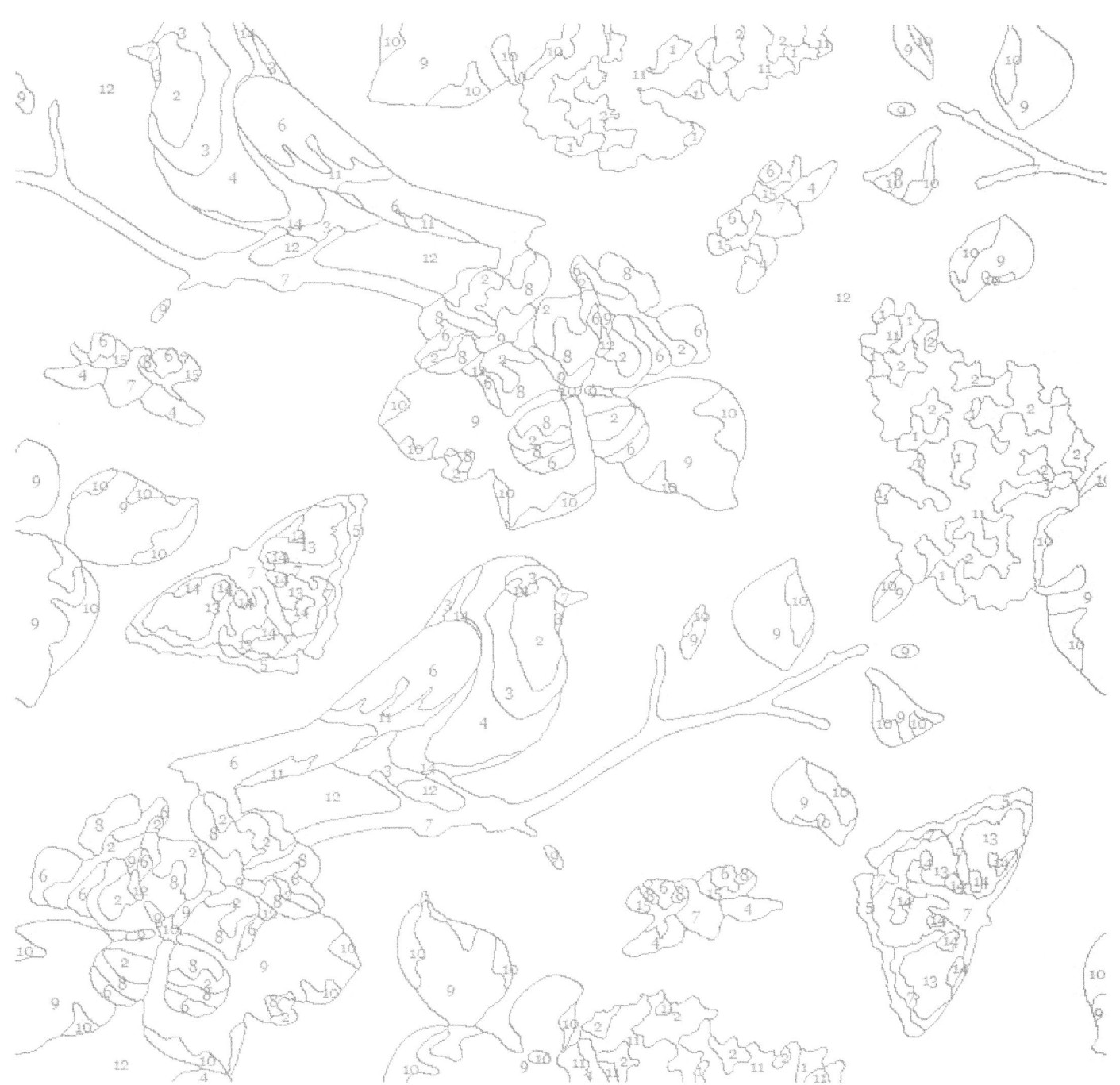

1. Red
2. Green
3. Blue
4. Pink
5. Purple
6. Light Blue
7. Light Green
8. Orange
9. Dark Red
10. Brown
11. Black
12. Dark Green
13. Gold
14. Violet
15. Yellow

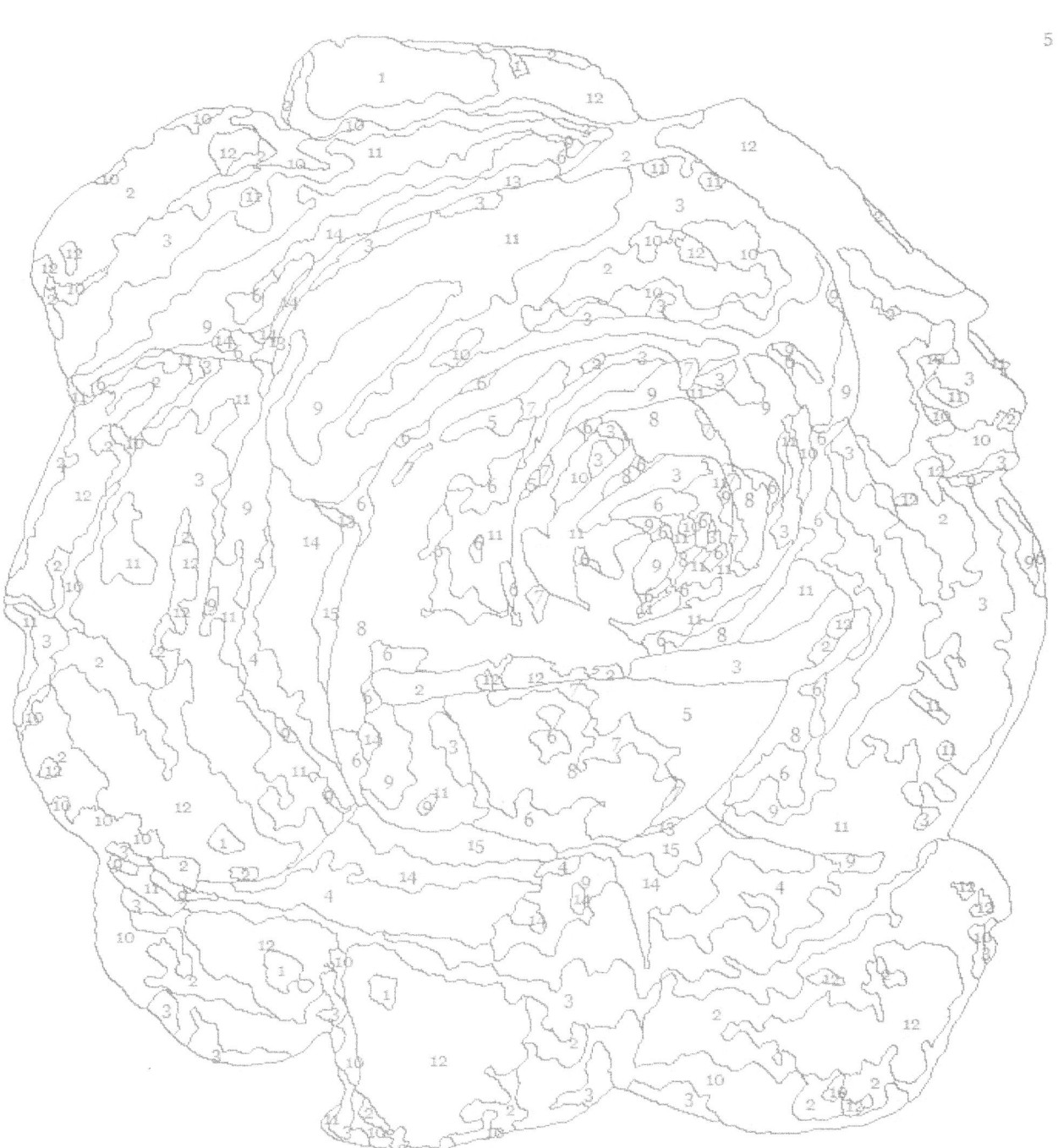

1. Red
2. Green
3. Blue
4. Pink
5. Purple
6. Light Blue
7. Light Green
8. Orange
9. Dark Red
10. Brown
11. Black
12. Dark Green
13. Gold
14. Violet
15. Yellow

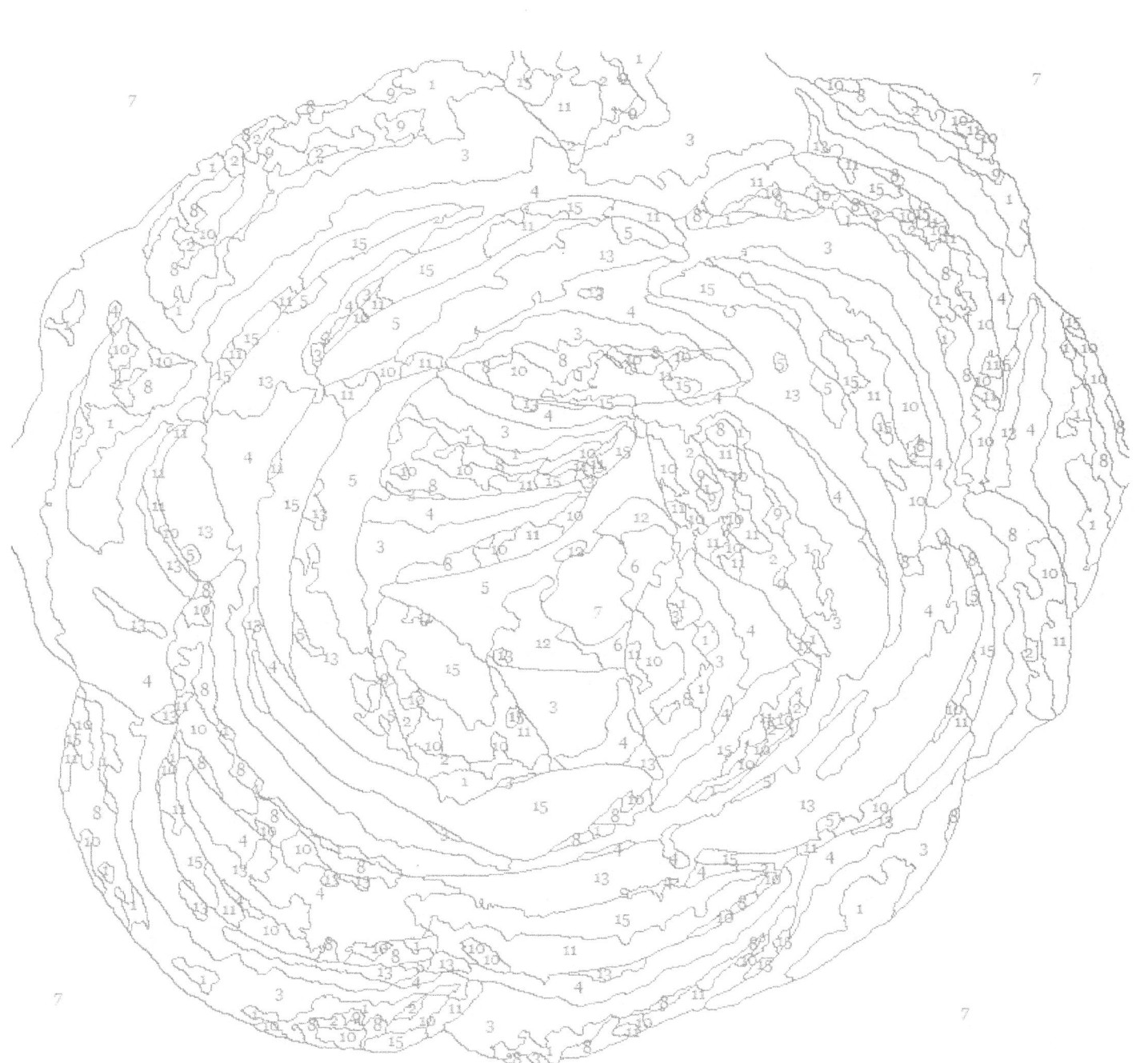

1. Red
2. Green
3. Blue
4. Pink
5. Purple
6. Light Blue
7. Light Green
8. Orange
9. Dark Red
10. Brown
11. Black
12. Dark Green
13. Gold
14. Violet
15. Yellow

1. Red
2. Green
3. Blue
4. Pink
5. Purple
6. Light Blue
7. Light Green
8. Orange
9. Dark Red
10. Brown
11. Black
12. Dark Green
13. Gold
14. Violet
15. Yellow

1. Red
2. Green
3. Blue
4. Pink
5. Purple
6. Light Blue
7. Light Green
8. Orange
9. Dark Red
10. Brown
11. Black
12. Dark Green
13. Gold
14. Violet
15. Yellow

1. Red
2. Green
3. Blue
4. Pink
5. Purple
6. Light Blue
7. Light Green
8. Orange
9. Dark Red
10. Brown
11. Black
12. Dark Green
13. Gold
14. Violet
15. Yellow

1. Red
2. Green
3. Blue
4. Pink
5. Purple
6. Light Blue
7. Light Green
8. Orange
9. Dark Red
10. Brown
11. Black
12. Dark Green
13. Gold
14. Violet
15. Yellow

1. Red
2. Green
3. Blue
4. Pink
5. Purple
6. Light Blue
7. Light Green
8. Orange
9. Dark Red
10. Brown
11. Black
12. Dark Green
13. Gold
14. Violet
15. Yellow

16. Red

17. Green

18. Blue

19. Pink

20. Purple

21. Light Blue

22. Light Green

23. Orange

24. Dark Red

25. Brown

26. Black

27. Dark Green

28. Gold

29. Violet

30. Yellow

1. Red
2. Green
3. Blue
4. Pink
5. Purple
6. Light Blue
7. Light Green
8. Orange
9. Dark Red
10. Brown
11. Black
12. Dark Green
13. Gold
14. Violet
15. Yellow